# Walking at Midnight

Meredith Sanders

Walking at Midnight © 2022 Meredith Sanders

All rights reserved.

Presentation by *BookLeaf Publishing*

Web: www.bookleafpub.com

E-mail: info@bookleafpub.com

ISBN : 9789394640849

First edition 2022

# DEDICATION

For those wanting to know that they are not
alone in their feelings.

# ACKNOWLEDGEMENT

I'd like to thank Brandon for always going on walks with me at midnight. You've always helped me find words to my emotions. Thank you for helping me along my journey.

I'd also like to thank my 12th grade English teacher, Melody Tenney. Thank you for making us perform our poems in front of the class and for helping me realize my potential in my own words.

# PREFACE

A glimpse into my soul is held within these pages. These are feelings and experiences I had during ages 10-19. I share my thoughts during my bouts of depression and anxiety, graduating, and finding myself. This book may contain some triggering topics such as self-harm and mental illnesses.

# Introductory Period

introductions
how do I sell myself to be more interesting?
how do I become an advertisement others would
acknowledge?
do I start with my name?
their name?
my interests?
their's?
how do I say what I need to say?
introductions bring internal destructions but
what do I say to the mirror?
how do I ask her about who she is?
what does she love? or need?
what will she think of me?
what will she think of my
introduction?

# hourglass

a ticking starts
I hear a timer in clocks,
silence,
breaths,
heartbeats.
a ticking continues
I'm running, I'm trying to catch up
what am I running towards?
what is out there?
my breathing intensifies and it gets
shallow
time
I need more time

## social interaction

eyes dart past me
I look at them
what are you thinking?
they look back at me,
a smile graces their lips
but their eyes look...
lost
lost in thought
thinking what?
is there something on my face?
do I look okay?
they must know something about me that I don't
why did they look away so quickly?
am I not interesting enough?

# static stability

the static builds up
the noise gains power over all else
all I can hear is,
static
I'm lost in the static but
I still manage to turn off the screen
the static disappears
where do my thoughts venture to?
there's no noise
nowhere to hide
nothing to cover up what's inside
I reach to turn the screen back on
it doesn't turn on
where is the static
will I ever have it back?

# Internal Affairs

"Enough!"
my heart cries
"I am trying to love and you are making it
difficult!"
"Why aren't you loving me?
my mind whispers
a pause
then,
"all that I'm doing is for you."

# Darwinism

survival of the fittest
how am I supposed to last
if I'm not built for this?
adapt
change
edit
life behind a screen spares no secrets
it's all a game
but I never learned how to play
do I lie?
or
do I tell my story?

# remembrance

it is time to come clean
darkness clouds my mind
it used to bathe my soul
but little by little
I'm learning how to light it
I turned to weapons to find peace
I turned to destruction
to stop the wars
I was shocked to walk
because memories of
attempts still exist
relapses were my therapy
until I found my voice
I no longer bathe in
darkness
but I still know it

# take it or leave it

I'm scared that I let you down
I could've tried harder
studied more
made more money
hung out with more friends
but I didn't
instead, I fought to recover
relearning how to avoid the tripwires strung
inside my head
relearning the aspects of reality
but also the falsehoods in truth
maybe I could have done more
to please you
but I did what I did
take it or leave it

## paying rent

breathe it in
can you feel it?
no?
breathe harder
let the feeling grow inside of you
let the air kiss your lungs
and make you not want to say goodbye
don't let the feeling part
instead, let it move in
make room for it
take care of your new roommate
that sense of newfound love
which is not for another
person
associate this feeling with
your breath
and keep breathing

# connect the dots

stop
lookup
close your eyes
let your mind run

dreams
mystical things
soft, quiet lullabies
of many heartbroken songs

prayers
sacred talks
forming lasting impacts
new dawn descends

# mortality

the celestial atmosphere
a learned state of being
a growing mindset
can be described as
heaven

a fallen state
forgetfulness
a tense and angry soul
mine used to live here

earthly existence
a difficult journey
choices and consequences
anxious yet fearless
shattered yet shining

# spinning

we mustn't forget the
reason why we dream
the longing we feel for something
new yet familiar
walking alongside you on the
sidewalk was so fresh
it felt as if you were straight
out of my dream
you spun me around
around and
around
we spun out of my dreams
I wake and hear you breathing beside me,
my never-ending dream

# sides of a coin

how many times do I forget the
sun?
the healing power of its rays
or
the damaging strength of its
light
it's always just a flip of a
coin
which side did I forget
or did I forget the whole coin?
I'm merely only human
and because of that
I tend to lose glimpses of
bright things

# opening night

and now here I am waiting
thinking,
should I have even bothered at all?
I don't know how to make it
passed simple introductions
I don't know where in the theatre
I should go
it's hard for me to just sit here
watching my lifeline drain
what will I do when the battery is gone?
where will my mind take me?
why do I get so scared of getting
misplaced?
I'm not sure how to function
I'm so out of my element
I'm not sure if I blame you
or me
for putting myself in this situation
where do I come in the mix of your people?

# consideration

it feels like an honor to be
considered
considered in life decisions
family excursions
and adding a plate to the table
I consider myself to be like an
extra
not necessarily wanted in these
aspects,
but merely a background character needed
for the plot
you all consider me as more
a puzzle piece needed to make
the big picture

# lingering

a feeling drew from together
sensing the energies and embracing
the vibrations
I'm wanting to stay put
but another part of me wants to continue
stepping away,
it all lingers
your presence is gone
but I still linger
reaching for your hand
come back to me
don't let me be alone

# indecisive

a
b
c
or
d
which choice do I make?
there are so many options
I don't know what to make
why can't you just tell me
what to choose
I'm not sure how to make a decision and
follow-through
with it
I second guess all of my choices
am I strong enough to make this one
on my own?

## desires

I wish I was more
I cannot accept who I am
until I am perfect
I need to meet the requirements
of being skinny
being pretty
intelligent
rich
and popular
until the,
I am not enough.
I torture myself by looking up
healthy aesthetics
falling down social media
rabbit holes
of comparison
I want to be better
how can I be better?

# grading system

not enough
it's not good enough
it won't ever be
enough
I'm being graded
every aspect of my life is
judged
wandering, watchful eyes are
landing on me
the grading system is never-ending
after the diploma,
it continues
how do I stop applying
the grades to my life?
I am no longer in high school
but grades are still applied

they don't have to be

# therapy

long waited
short-lived
profession help
hour-long calls
hour-long cries
medication failures
medication progress
identifying patterns
aspired improvement

almost a year without
I've lost all of my progress
where is the marked path back to
recovery?
am I meant for that life?
I know...

I need therapy

# living history

"Welcome,"
a joyous occasion
arrival
a moving expression
combine the two and it's
being greeted at the door
the shuffle of movement behind wood
the turning noise of the handle, and
a smile on your face
and I am welcome.

I'm shown glimpses of your
living history
on the walls and in the lines on your face
a life well-lived,
a family well-loved.

an introduction worth making,
clocks hang on the walls, but
the tick doesn't stop me.
meeting with friends and with strangers,
finding stability when there is
nothing.
stopping the internal wars, and turning them
towards
peace.

becoming the best you possible.
remembering the past, and
acknowledging it.
accepting what you had to do, and
that it is enough.
making room in your life for
love.
searching for powerful connections,
resolving fights in your mind, and
simply just existing.
locating the pot of gold in
a storm
following the bright things,
combatting the fear of loneliness,
becoming involved in a new setting.
feeling things you've never felt before.
formulating decisions and holding to them.
desiring who you should be,
but becoming better than any dream or idea.
ignoring faulty grading systems that are meant to
destroy,
and finally,
meeting with a professional to get to where you
need.

it is I who welcomes me at the door.

I am her living history.

CPSIA information can be obtained
at www.ICGtesting.com
Printed in the USA
LVHW030338110922
728042LV00009B/607

9 789394 640849